Life
as I See It...

BETTY ADORNO RIVERA

Order this book online at www.trafford.com
or email orders@trafford.com

Most Trafford titles are also available at major online book retailers.

Printed in the United States of America.

ISBN: 978-1-4269-6514-2 (sc)
ISBN: 978-1-4269-6515-9 (e)

Trafford rev. 05/19/2011

 www.trafford.com

North America & international
toll-free: 1 888 232 4444 (USA & Canada)
phone: 250 383 6864 ♦ fax: 812 355 4082

About the Book/Overview:

This book of poems is based on my own real personal life experiences as well as others. I focus on what I feel at the time, what I have experienced, or what someone else has experienced. I write on subject matters that relates to abuse, cheating, everyday life struggles, and what can be done to take charge of that moment. All of my poems have meaning and messages to help others visualize a situation that may have had an effect on their lives with possible resolution.

My poems are intended to inspire and motivate others as I have been inspired to write them. My voice speaks out loud to represent those who are fearful to speak for themselves. If I can reach out and touch somebody and make a difference in their life, then I feel that my work was worth sharing. My inspiration and motivation comes from my loving husband who came to my rescue at a time when all was dark and empty in my life, and my children who gave me reasons to want to live. The fact that I was living in a violent environment with the possibility of putting my children at risk gave me the strength and courage to take control of my life.

I write poems as a medicinal tool to help heal my wounds internally and emotionally. It allows me to tell a story and controls my mental state of mind by putting it at ease and peace. These crucial changes allowed me to have the peace of mind that I have today. I have some good memories which I will always embrace and treasure, but had more bad than good that will never be forgotten.

Dedication

In dedication to my mother Luz Maria Mitchell, who fought so hard to live as with everything else in her life. She fought like a soldier, but lost the two year battle with a vicious cancer, which sadly overtook her life on October 15, 2011. My mom motivated me to fight hard for what I believe in, to embrace life, love it, and live it. She told me to be at peace with myself, for that's where it starts and will gracefully spread. Peace has brought me happiness, stability, and alignment in my life.

Knowing that my mom accepted death to be in peace in another life helped me to understand the importance of peace even more. She will always be missed and the wonderful memories I have of her will always be embedded deep within my heart. I LOVE YOU MOM!

Table of Contents

Ashes to Dust 1
Code of Silence 2
Code of Silence (Image) 3
Dear Mom 4
Dear Mom (Image) 5
Cheaters Never Prosper 6
Deceit 7
His Chain Has Broken 8
His Chain Has Broken (Image) 9
I'm That Superwoman 10
I'm That Superwoman (Image) 11
Divinity 12
Don't Get Burned 13
It's Just A Dream 14
It's Just A Dream (Image) 15
Love Junkie 16
Love Junkie (Image) 17
Find the Way 18
Friendship Values 19
Make Your Mark 20
Make Your Mark (Image) 21
My Eyes 22
My Eyes (Image) 23
I Am Blessed 24
I'm Coming Home 25
My Guiding Light 26
My Guiding Light (Image) 27
Not Defeated 28
Not Defeated (Image) 29

Learn To Communicate 30

Life Is 31

One Last Time 32

One Last Time (Image) 33

Pain Prayer 34

Pain Prayer (Image) 35

Listen To Me 36

Love Hurts 37

The End of the Line 38

The End of the Line (Image) 39

The Final Chapter 40

The Final Chapter (Image) 41

No Regrets 42

Promises, Promises 43

The Fire In You 44

The Fire In You (Image) 45

The Forbidden Fruit 46

The Forbidden Fruit (Image) 47

Release Me 48

Remember 49

Things to Ponder On 50

Things to Ponder On (Image) 51

Treasured Memories 52

Treasured Memories (Image) 53

Secrets 54

The Forgotten Ones 55

Triumphant 56

Triumphant (Image) 57

Victory Is Mine 58

Victory Is Mine (Image) 59

The Polluted Mind 60

The Power of Love 61

What Is Your Purpose? 62

What is Your Purpose (Image) 63

Time to Come Together 64

Words To Live By 65

Yes, I Can 66

Ashes to Dust

Dogs are to bones, as cats are to nips...
Love is to broken hearts, tears are to drips...

Water is to waves, as nature is to amazing...
Ice is to cold, as fire is to blazing...

Clown is to circus, as laughter is to a joke....
Working is to money, as paying bills is to be broke...

Patience is to virtue, as anger is to dispute...
Listening is to hearing, as silence is to mute...

Remember is to memories, as misplaced is to forget...
Embrace is to treasure, as mischief is to regret...

Brain is to intelligence, as wisdom is to wise...
Cloud is to sky, as heaven is to paradise...

Forgive is to thy enemy, as respect is to thy friend...
Life is to a beginning, as death is to an end...

Family is to togetherness, as friends are to trust...
Ashes are to ashes, as dust is to dust...

July 30, 2009

Code of Silence

Hush, be silent, and please don't say a word...
The right solution is not to be heard...

Nod your head, make a gesture, and just give a smile...
Keep it quiet, don't waste your breath; anger starts to pile...

In the past, speaking up, caused conflict and so much drama...
Feeling as if in a debate, like Palin versus Obama...

It may be very tempting to talk or disagree...
I wish I could be understood and just be me...

No opinions, no advice, no, that's not allowed...
"I won't ever speak my mind," I promised and I vowed....

Breaking the code of silence is like breaking the biggest rule...
Bite your tongue, clench your teeth, be stubborn as a mule...

Is it worth the effort to get upset and stressed?
I'd rather be in silence and totally be depressed...

July 19, 2009

Code of Silence

Dear Mom

Just want to say what's on my mind; how I really feel...
The love that I have for you is so special and very real...

We had memorable moments, both bad and good...
Some which I learned from; some left misunderstood...

We went our separate ways, and moved on to excel...
My life was so empty; you were blinded and couldn't tell...

I went through some struggles, and made some mistakes...
Mistakes like trusting friends, who turned out to be fakes...

Thank you for the tough love and showing me right from wrong...
It made me who I am today, a woman so tough and strong...

One thing I realized and will take with me to the end...
You were a great mom, companion, and my very best friend...

Right before my very eyes your time seems almost near...
You're fighting like a soldier, so bravely with no fear...

Why does life come to an end? God has that answer...
Why does mom suffer so, from this fatal disease called cancer?

What can I do, or say, to comfort her from this torturous pain...
Pray to God is what I'll do to break this devilish chain...

He'll touch you very gently to give you full relief...
He'll comfort you and heal you from illness is my belief...

It's up to God to save you; your life is in his hands...
He's our mighty savior, with miracles on his commands...

March 11, 2009

Dear Mom

Cheaters Never Prosper

Real men don't give into temptation; they don't cheat...
They worship the ground we walk on and kiss our very feet...

Cheaters think with their genitals instead of using their brain...
Looking for fights and drama; inflicting torturous pain...

Cheaters are insecure and bite more than they can chew...
They should learn from real men, so limited and very few...

Know what you have is special and can be lost for good...
Treat her with love and respect; reveal your true manhood...

Don't take us for granted and believe we'll forgive and forget...
That kind of ignorant thinking is what later you'll regret...

If cheating didn't exist the world would be a better place...
Royalty you'll be treated as with more to love and embrace...

Real men will fight for love doing whatever it takes...
Making us happy and comfy by avoiding costly mistakes...

Cheaters never prosper; cheating themselves of love...
Faithfulness and trust is key when push come to shove...

June 26, 2010

Deceit

I really thought you were my friend...
Friends stick together until the end...

You lied, deceived me, and lead me on...
Those trusting days are totally gone...

I can't believe you let me down...
My facial expressions changed from smiles to frown...

Don't call or look for me; I won't be there...
This pain I'm enduring is too hard to bear...

You broke my heart and made me weep...
Kissing my boyfriend went far too deep...

You're not my friend, you broke the rule...
You took me for granted; I'm not a fool...

I'll never forgive you, so leave me alone...
Go back to your doghouse and chew on a bone!

January 19, 2008

His Chain Has Broken

You are evil and cold as ice...
Get some help and good advice...

Your venom is potent; it's making him sick...
The pain gets stronger; he'll die real quick...

Vindictive are you; won't stop at nothing...
Hate in your heart is all that you bring...

Your devilish ways has made you hollow...
What you created will haunt you and follow...

Your life with him no longer exists...
No need to fight put down your fists...

Unhappy was he; you didn't care...
You didn't play nice; you weren't there...

He finally found love and moved on to excel...
Your jealousy led you to cast him a spell...

Love's not meant for you; it wouldn't have lasted...
Reverse the spell which you have casted...

It doesn't matter; our love is greater than strong...
We'll count on God and prove evil is wrong...

The poison has weakened, his chain has broken...
"Pain is no longer!" for God has spoken...

August 29, 2009

His Chain Has Broken

I'm That Superwoman

I'm that superwoman, who proudly wears a cape...
No time for relaxing or unwinding for an escape...

I'm that superwoman, who boldly wears a shield...
To guide and protect you, put a halt to all and yield...

I'm that superwoman, who fearlessly uses super powers...
To fly over mountains, fight battles, and climb towers...

I'm that superwoman, who securely wears a vest...
A sign of security and trust when I am at my best...

I'm a superwoman, who creatively makes magic...
To make things disappear when hectic and tragic...

I'm that superwoman, who boldly wears a mask...
Hiding my identity and issues become my biggest task...

I'm that superwoman, who fiercely wears her tights...
It's part of my disguise that gives me appealing sights...

I'm that superwoman, who genuinely carries a name...
They call me the superwoman who has no fear or shame...

May 27, 2010

I'm That Superwoman

Divinity

A lost, and confused soul was I...
Living a life of hell I just wanted to die...

I prayed for him to disappear, and leave me alone...
Was always scared, and stiff as a lifeless stone...

With no where to run, and no where to hide...
Took physical, and emotional punishment, and consistently cried...

Desperately I pleaded, "No more suffering, no more pain!"...
"I have a life ahead of me, yet to gain!"...

Suddenly my prayer was answered, and my spirit was lifted...
That horrid dark part of my life has finally drifted...

Met a wonderful man who is funny, yet very wise...
A man so sweet, and comforting, brought my morale to a rise...

Packed my bags, never looked back, and finally moved on...
Thank God that chapter of my life is over and totally gone...

From that point on, time has passed, and all is divine...
He asked for my hand in marriage and he's mine all mine...

I'm in blissful peace; live happily ever after with my hero...
Because he gave me strength, and courage to drop that zero!

November 29, 2008

Don't Get Burned

So I hear that drinking and smoking takes away the pain...
It hides those horrible memories we can't forget or sustain...

Dwelling on problems worsen by then becoming an obsession...
Another problem is then created which lies in your possession...

There are better ways to deal with these pestering issues...
Time to face reality; no more crying and wasting tissues...

Don't follow the cycle of being a follower instead of a leader...
Your future is in your hands only so drop that psychic reader...

Breathe deep and let the inner you out; let it flow...
Let your innermost glimmer and shine; let it glow...

Don't let your mental wires cross, keep it grounded...
Focus on positive things that will leave you dumbfounded...

Someone I knew drank and used drugs; all the wrong things...
It wasn't my addiction and that's what hurts and stings...

It stung so much because it emptied out my pockets...
My hard-earned money went as quick as soaring rockets...

This someone I feared, so I complied; I had no choice...
One day something inside me resisted; it was my inner voice...

It was a sucker punch to the face that couldn't be ignored...
I found a way out as I searched for answers and explored...

It was an awakening for me; don't get burned in the fire...
To love and respect yourself should be your only desire...

March 3, 2011

It's Just A Dream

I'm in a very good mood, so please leave me alone...
No emails, no music, and definitely no phone...

I'm always working hard, no time to play any games...
So many charts, so much to do, so many patient names...

I have no motivation and always feeling tired...
Got to keep it moving before I get fired...

It starts with a beginning and feels like there's no end...
Too much work, little pay, it just doesn't blend...

After work, I clock out, and my day is not yet over...
I run home to cook, clean, and feed my pet dog Rover...

Waking up to fight traffic, it's all the same routine...
I'd much rather ride on a cool stretch limousine...

I wish I could retire, or better yet, hit lotto...
"Let the spending begin", would be my only motto...

For now it's just a dream that only costs one dollar...
I'll keep on playing and when I win, I'll be screaming
Hollar!!!!

August 21, 2008

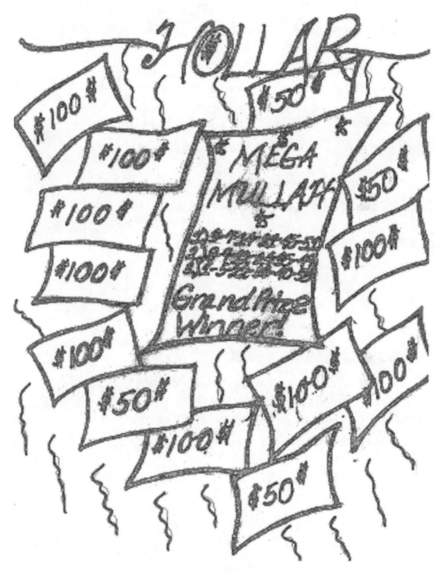

It's Just A Dream

Love Junkie

Making passionate love is good and bitter sweet...
It tingles the entire body from head to your feet...

The touch is so gentle and kiss very tender...
Hypnotized from love, don't want to surrender...

Emotions get stronger, the feeling gets better...
Your legs will get weakened, the body gets wetter...

Love is medicine; it cures all kinds of pain...
It heals the wounded soul and restores the tired brain...

It's very addictive; makes you want much more...
The sensation is intense, get ready to finally score...

Getting ready to climax; temperature is rising...
Going to explode; my position is revising...

Pushing to give all you got, to the full extent...
Call me the love junkie; I crave the love scent...

By force of nature, the volcano will soon erupt...
Here comes the lava flow, so fiercely and abrupt...

August 28, 2009

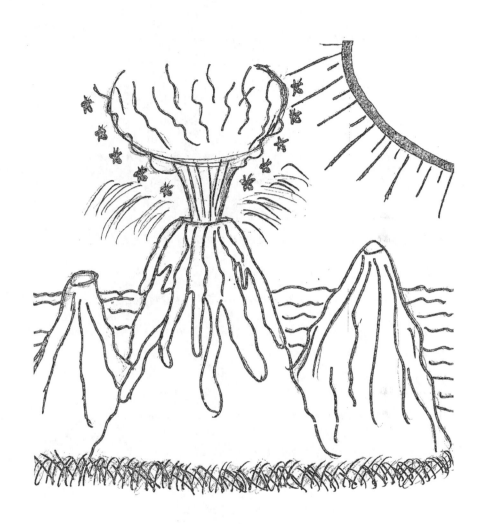

LOVE JUNKIE

Love Junkie

Find the Way

May our love grow stronger every passing day...
May it burn with passion, let us find the way...

Should you choose to go in another direction...
Remember, love is what matters, not perfection...

Thank you for being there in my times of despair and need...
My love for you blossomed from the start of a seed...

Remember how we came to be, I'll never forget...
The way you embraced me and how our lips first met...

I asked for someone like you in my dreams and prayers...
Our love and happiness will build on layer upon layers...

Your generosity and kindness spoiled me rotten...
I'll love you forever; you'll never be forgotten...

I will always cherish the times we spent and shared...
You said you loved me, and showed how much you cared...

Today should be solely about you and me...
Let bygones be bygones; just let it go, let it be...

What is our destiny, what is in our future...?
Repair what is broken with a stitch or suture...

Let's light some candles and make some magic...
Make it happen to this love so fierce, yet so tragic...

Friendship Values

I value our wonderful friendship; it means too much to me...
The talks we share together guide me to visually see...

I see from a different perspective, when all seems wrong and unfair...
It clears my clogged up conscious, when it's full of sorrow and despair...

It eases the mind and cleanses the soul, all will unravel...
Trust is a must, be loyal, and don't forecast news that'll travel...

Your secret is safe and sacred to me; my lips are tightly sealed...
I'll just listen, mind my business, and nothing gets revealed...

No need to worry, don't bite your nails, there's no need to fear...
Circumstances get fixed and erased as fast as they appear...

Friendship is not like auto parts, which wear out and get replaced...
It's beautiful like a genuine gem; it's cherished and well-embraced...

Be true to your friends, genuine and real; don't cross the crooked line...
Your truthfulness and loyalty makes friendship glow and shine...

The value of friendship is golden and could never be compared...
It's an exchange of expression and feelings to trustfully be shared...

January 25, 2010

Make Your Mark

The clock moves fast and goes tick-tock-tick...
At the blink of an eye, time goes so quick...

Where has it gone? It came and went...
Will you make your mark, or will you leave a dent?

Be a winner to have something to embrace...
Only time can tell, if you can win this race...

Don't lose the battle, there's much to gain...
No time to lose, for little time will remain...

Stop wasting time and chant, "I believe!"
Life offers much to grasp, treasure, and retrieve...

There's no time, or room for error...
Evil brings you down and is full of terror...

Stop making excuses, it's not allowed...
"I'll be a success", I prayed and I vowed...

Look for motivation, for it's a powerful source...
Seek for positive energy, for it's a thriving force...

Look forward to the future and make your mark...
Don't stay in the clouds, and don't be in the dark...

August 28, 2009

Make Your Mark

My Eyes

My eyes were meant for gazing; for that I'm not ashamed...
Admiring the beauty of all creation; for that I can't be blamed...

The sky is blue, full of clouds, and always in constant motion...
The way that all came to be was part of God's devotion...

The moon has a luminous glow that makes you want to stare...
Amazing is this pleasant sight, which has a powerful glare...

My eyes I close to reminisce and capture good old times...
Reading stories to my kids and singing nursery rhymes...

My eyes will drift and shut down tight before I fall asleep...
I toss and turn, kick and twitch, I even count some sheep...

My eyes were blinded, I made mistakes, in which I can't take back...
There were no colors in my life except for white and black...

Don't judge me by appearance; no answers there to find...
Look deep, down into my eyes, you'll see my heart and mind...

My eyes are full of tears and pain for reasons unexplained...
Haven't gone bananas yet, but feeling tired and drained...

My eyes are made for learning; it guides me all the way...
It helps me see the value of life every night and day...

November 10, 2009

My Eyes

I Am Blessed

I am blessed for the abundance of love that you give...
I am blessed with life; the reason and will for me to live...

I am blessed for being an opportunist; one to receive...
I am blessed for having courage and faith to believe...

I am blessed and honored to truly have been graced...
I am blessed with my children; they're treasures I've embraced...

I am blessed with you; the impact to all, that's good in my life...
I am blessed with strength to face struggles, challenges, and strife...

I am blessed for being lead to the right path, the right direction...
I am blessed to be in a world full of love, with little imperfection...

I am blessed to have lived through this hard and torturous journey...
I am blessed to have God on my side; he's my witness and attorney...

I am blessed with answered prayers; expeditiously and right on time...
I am blessed with his presence; so admirable and sublime...

I am blessed to have a man with knowledge; one who's very smart...
I am blessed forever, for he has deeply touched my heart...

February 21, 2008

I'm Coming Home

Home is where the heart is and where I choose to be...
Togetherness and family; I truly miss that part of me...

There's so much love and freedom; it gives so much pleasure...
Embracing all the memories and times which I treasure...

Here is not the place for me; tired of feeling alone...
Reaching out to family by internet and phone...

Thinking it would help me to ease my boggled mind...
Instead, I find it torturing me wanting to leave all behind...

My drive is gone, my mind is absent, and I have no more desire...
I'm feeling very homesick; my heart is inflamed with fire...

My mom and dad I'll always love, but I truly miss my home...
It's sort of like a baseball game with no stadium or dome...

My hot tropical island is the home where I belong...
It's what makes me happy, healthy, and very strong...

I swear I'll make an effort to end this mental stress...
Determined to work harder to save and leave this mess...

"There's no place like home," it's true and how I feel...
Nothing is going to stop me; my shield is hard as steel...

I'm coming home so make some space and let the fun begin...
I'll celebrate with hugs and kisses; I'll have my way and win

May 11, 2010

My Guiding Light

A good woman has passed and found her way to heaven...
The eldest and strongest from siblings totaling seven...

With beautiful eyes that sparkled and lit wherever she stood...
Like a genie from a bottle, she blinked and all was good...

Her beautiful name Luz, in translation means light...
A name so well-suited for one who loved Christmas night...

She attracted many through the lights of her Christmas house...
The carousel, reindeers on her roof, and Minnie with Mickey Mouse...

The lights that brought togetherness was the greatest attraction...
Lights that brought joy and warmth with great satisfaction...

A line full of strangers with eyes full of glare and glimmer...
They watched with a smile until the lights just got dimmer...

A guiding light to me she was when life was cold and dark...
Luz resembles the light we embrace forever leaving her mark...

Her name has illuminated and prepared her for her path...
Surrounded by peace and love as part of the aftermath...

No more pain and suffering; your destiny has been fulfilled...
You're in a better place for the good-hearted and strong-willed...

The same light she aspired is the same light she entered...
Forever, now in paradise a portrait so carefully centered...

October 26, 2010

My Guiding Light

Not Defeated

My life was in shambles; it's fallen far apart...
My mother tried to warn me, from the very start...

Ignoring all the signs, from when it first began...
Didn't have a keen eye to look, observe, and scan...

Life won't get the best of me; I'm not yet defeated...
Abused and beaten, was cheated and mistreated...

I didn't have the courage, was fearful and so weak...
Grew tired, weary, and desperate; for freedom's what I seek...

If I knew then what I know now, my life would be complete...
The pain that I endured and faced would be so obsolete...

Did not deserve this treatment, it's all a mystery...
Awakened from that nightmare, I made it history...

Nothing ever is written in stone, so here is some advice...
Make crucial changes, don't get defeated, and make that sacrifice...

July 26, 2008

Not Defeated

Learn To Communicate

I know what I'm saying; to me it makes much sense...
To you it's just some gibberish that makes you get so tense...

If you stopped and listened, you may just hear me right...
You could avoid the problem from turning to a fight ...

Time and time over you tend to do the same...
Yell and scream is what you do; what a big darn shame...

Learn how to communicate; it's really not that hard...
Listen to every word I say, respect and have regard...

Trying to explain myself the best way I know how...
You interrupt, yell some more, I want to choke him now!

Doesn't matter what I say; it's all to no avail...
I'll be quiet, won't say a word, for all else will fail...

September 19, 2008

Life Is

Life...........

Is a struggle and hard to understand...
Is a never-ending cycle, so beautiful and grand...

Is too short to embrace or even to enjoy...
Is timeless and disallows us to be coy...

Is so full of unbelievable surprises...
Is measured in all kinds of shapes and sizes...

Is all about making real valid choices...
Is about tuning out the negative voices...

Is very secretive and yet, so discreet...
Is beyond our imagination and right before our feet...

Is very challenging and full of mystery...
Is full of sadness, tears, and history...

Is very valuable and meaningful to us all...
Is what decides if we should rise or fall...

Is what has a beginning, and really has no end...
Is what we make of it, but difficult to apprehend...

August 23, 2008

One Last Time

Your little girl is all grown up and so full of life...
The girl you loved and nurtured, will soon be a wife...

The little time you spent with me, forever will be treasured...
Your time was cut so short from me; time that can't be measured...

I woke up on a gloomy day and didn't find you there...
You said, "I'm not gone baby girl, so please don't despair!"...

Never got to parting words, your smile is what I'll miss...
Never got to hug you tight and give you your last kiss...

"Daddy I wish I can see, and touch you, for one last time...
I'd trade that for anything in this world, at a drop of a dime...

I'll be devastated, full of sorrow, the day I walk that aisle...
My special day won't be the same without your gorgeous smile...

You'll always be alive to me, for you are in my heart...
Nothing ever in this world will bring us far apart...

January 6, 2008

One Last Time

Pain Prayer

I'm a living pain box with no remedy and no cure...
Pain that depresses me, pain that's so obscure...

Can't function properly; always in so much pain...
Pain that makes me suffer so, pain I can't sustain...

Always taking medicine; nothing seems to work...
Forgetting what it is to smile, I can't even smirk...

Someone please help me; take this pain away...
If not, take my life and let me rot and decay...

I can't stand it any longer; can't take it anymore...
I want to be normal to love the one I adore...

If given one wish, I'd ask for a new body and life...
Instead, I live with pain sharp as a stabbing knife...

I'm a good person who lives by all the rules...
A father with children all stubborn as mules...

Teaching them lessons, they got on my nerve...
Can't figure it out; this is pain I don't deserve...

May God forgive me and continue to make me strong...
I made mistakes in life; mistakes I admit were wrong...

Please answer my prayers; won't question your quest...
Make me whole and healthy; it's my only small request....

October 3, 2008

Pain Prayer
Please Take My Pain Away!...

Pain Prayer

Listen To Me

Listen to the quiet and soft whispers of the wind...
Listen to prayers of forgiveness as a means to rescind...

Listen to the fast beats of a broken heart pounding...
Listen to the squabbles of God's creatures; sounds so astounding...

Listen to the flowers as they wilt and blow away...
Listen to the tear drops fall; so full of pain and dismay...

Listen to the crying infant in need of your care and tender love...
Listen to our creator work his magic from the heavens up above...

Listen to your parent's advice, for it might be too late...
Listen to your positive thoughts, for it's your destiny and fate...

Listen to the angry rivers respond with a vigorous splash...
Listen to the burning inferno of flames turn into ash...

Listen to the ticking of the clock, for time is the essence of all...
Listen to the simplest things that matter, whether big or small...

Listen to everything important in life that you were told...
Listen to me, for there may not be a tomorrow to behold...

August 16, 2008

Love Hurts

Why does love have to hurt so bad...?
It's driving me crazy, it drives me mad...

I can't breathe, or even concentrate...
Is this true love and my true soul mate...?

Why am I so fearful, nervous, and afraid...?
Afraid that he'll leave me, perhaps I'll get played...

Nothing in my life has ever felt this great...
He takes me to another world to think and contemplate...

It feels like a dream; sounds too good to be true...
I do deserve this love, this love so fresh and new...

"The feeling is mutual", says this wonderful man...
"Just love me, trust me, and hold my hand."...

It is in our nature to feel this kind of pain...
It makes us do crazy things; it drives us insane...

Please don't be misinformed or misunderstood...
These pains are like having butterflies, pains that feel good...

What is a solution to stop from feeling this way...?
Keep the fire burning to survive another day...

Whatever the outcome, I'll take it easy and call a friend...
Life has better things in store for me; it is not the end...

December 6, 2007

The End of the Line

I was at the end of the line, before I got swept off my feet...
My prince charming rescued me to make my life complete...

A chance for a new beginning and to surrender all the old...
A time to embrace my freedom worth far more than gold...

Showered with gifts and flowers; he gave me so much love...
He wrapped me tight in his arms and said I fit like a glove...

Time drifted slowly; we're bonded like sticky glue...
Colors of the rainbow faded; darkness will subdue...

I saw it from the moment he lost his shine and glimmer...
I felt the brightness of our love getting dimmer and dimmer...

We're just happy and content; he took that for granted...
The magic is weakening; the fairytale is no longer enchanted...

Our lives were once filled with adventure, excitement and rapture...
His smile is what bedazzled me; moments I'd like to recapture...

I was at the end of the line, started over, now I'm in the middle...
Lack of communication started this mess; it's a mystery and riddle...

His trust is now in question and the lies begin to pour...
The late nights out became too much; this concludes his tour...

I'm back to where I started from at the end of the line...
Relationships grow on love when you're honest and genuine...

April 23, 2010

The End of the Line

The Final Chapter

Today, I'll love you same as tomorrow...
Today, I'll cry the tears of sorrow...

Today, you'll kiss me and be on your way...
Today, I'll be speechless with no words to say...

Today, my mind will be full of confusion...
Today, love will end with a sad conclusion...

Today, you will deeply break my heart...
Today, we'll say parting words and then depart...

Today, I'll be ready to wipe my tears...
Today, I'll stay strong and face my fears...

Today, the final chapter will come to a close...
Today, I don't expect for him to propose...

No more today, tomorrow, or future...
Today my heart will need a big suture!!!

September 21, 2008

No Regrets

I may not be perfect; I too have flaws...
But, I love you, respect you, and obey the laws...

Please stop all the fussing, don't lure or scare me away...
Don't want to depart from you; I really want to stay...

We have grown together and let our lives evolve...
Don't always have answers for problems to solve...

Run fast through the hurdles, to cross the finish line...
To reach to the point where it's quiet and divine...

Can we finish this hurdle that is so hard to reach...?
Will we make it to the next level, to learn and teach...?

Communication is like changing channels on a tv set...
When something is not agreed on, flick it with no regret...

We change the channels together, until we both agree...
To a channel that makes us happy with solace and glee...

Not meeting you sooner, is the only regret I've had...
I felt life has cheated me and treated me very bad...

Our love will only get stronger before it gets weak...
Some challenges we'll face, before we reach our peak...

May God please bless us, and continue to make us strong...
May no evil bring us down, or do us any wrong...

May 18, 2009

Promises, Promises

You promised to love me, til death do us part...
In sickness and health, you'll be my sweetheart...

You swore on the oath to respect and care...
To guide me, protect me, be just and fare...

You promised to be faithful, honest, and clean...
To be my best friend and never be mean...

You vowed to make me happy, and give me life...
To join me at the altar and make me your wife...

You swore to be patient, peaceful, and humble...
To never give into temptation, fall, or stumble...

Promises, promises that's all you make...
Taking me for granted was a big mistake...

The picture you painted was fictitious and untrue...
You got caught cheating; God came to my rescue...

Kept my end of the bargain, and stayed by your side...
Was loyal and respectful, but you took me for a ride...

I love you dearly, but I cannot forgive...
Just wanted to be happy, just wanted to live...

You didn't respect me; I no longer have trust...
You gave into temptation, promiscuity, and lust...

I guess that promises were made to be broken...
It was only a dream from which I have awoken...

October 14, 2009

The Fire In You

There's never a dull moment, when I'm alone with you...
Plenty of smiles and laughter with feelings of déjà vu...

We go on trips, have some fun, and make up for lost time...
Released from all the stress, and cleansed from dirty grime...

There's staring and gazing, like never seen before...
Something about you just makes me want some more...

You wine me and dine me; treat me like a queen...
You have eyes like a hawk; so sharp and, yet so keen...

Your knowledge and wisdom, I truly do admire...
You make me shake and quiver; and set my heart on fire...

You make me squirm and glitter, as I luminously glow...
When you whisper in my ear and there you softly blow...

Make no mistake; this fire of love will always have a spark...
What the future beholds for us, we'll cherish and embark...

July 19, 2009

(the Fire In You)

The Fire In You

The Forbidden Fruit

Relationships are wonderful and can be quite confusing...
It alters our emotions from sad to happy and amusing...

There are men with baggage and baby momma drama...
Those who inflict emotional pain causing mental trauma...

Can I make a difference and be all that he needs?...
Selfish of me to think that way when men just plant their seeds...

I feel like I'm in training, a private, or a new recruit...
This is all new to me; He's untouchable and "The Forbidden Fruit"...

Knowing what I was in for, I gave this love a shot...
I love this man so dearly; I'm giving it all I got...

Respect is so important to me and something I demand...
It's something that brings togetherness and bonds us hand in hand...

If I don't see any changes, I'll leave sadly with no regret...
All the good and bad times, I definitely won't forget...

You will learn your lesson; No woman will take your crap...
They too, in time will leave you and call your drama a wrap...

February 23, 2009

The Forbidden Fruit

Release Me

Can't seem to find myself; I'm so confused and lost...
Precious time was wasted and became the ultimate cost...

I need to find my way out, before it gets too late...
The clock keeps ticking quickly; time will dissipate...

No more games or excuses, there's no room for error...
My life was distracted with drama, deceit, and terror...

The past still haunts me and follows me all around...
It tortured my emotions, deeply and so profound...

Will things go back to normal and release me from this pain...
Total peace and happiness, is what I'd like to obtain...

The hardships that I battled made me wise and strong...
Got to erase the horrid past, start over, and just move along...

February 23, 2009

Remember

The first time I held you; was beautiful and felt so good...
Learning to love and nurture you was part of motherhood...

I can't believe how fast, time has passed us by!
You were so inquisitive, asked questions, including why...

I spanked and punished you; taught you right from wrong...
We went through some hard times; times that made us strong...

You're all grown up now, entering a new phase in life...
You'll go through struggles, challenges, and possibly strife...

So valuable are these lessons; they'll pay off in the end...
Through it all I discovered, that you are my best friend...

Remember all you learned, its' value can't be bought...
I won't be here forever, remember the fights we fought...

I'm sorry if at times, I was harsh, and very strict...
Those times made you angry, annoyed, and even ticked...

Here's the last piece of advice, as a parent, I want to give!
Be responsible, live life to the fullest, have fun, and just live!

Remember me always, you're the children I cherish and adore...
I love you dearly, always, and forevermore!

December 4, 2007

Things to Ponder On

The pen is mightier than the sword, and so they say...
Words to me are mightier, for it holds truth and way...

Better late than never sounds believable, yet very clever...
Better now than later brings love and joy that lasts forever...

There are more fish in the sea, and maybe that's true...
No better are those creatures and beasts from the deep blue...

The more the merrier sounds good when you're rich and wealthy...
Some cannot afford more; it makes them broker and unhealthy...

Good things come to those who wait, sounds encouraging...
What about those who die waiting; now that's discouraging...

The life you save may be your own, sounds believable...
Only God can save you; life that once was conceivable...

Take it one day at a time may help alleviate stress and pain...
How much time do we have? A question to pick your brain...

April 8, 2010

Things To Ponder On

Treasured Memories

Memories are treasures and keepsakes of our past...
Kept forever within us, and made to always last...

In our hearts and our souls is where they'll remain...
Buried deep inside are moments of love, hate, and pain...

Christmas is my favorite day, which falls in late December...
Surrounded by togetherness and love that I'll remember...

Mortality is inevitable; one we fear to face...
Our special thoughts and feelings, we cherish and embrace...

No matter what memories are stored; whether new or old...
Memories are always with us, and worth far more than gold...

August 30, 2008

Treasured Memories

Secrets

I am not convinced of his trust, or his loyalty...
The goddess that I am should be treated like royalty...

The skeletons in his closet have not yet been revealed...
It's locked up in his memory and tightly so concealed...

There should be no secrets when all is divine...
The love gets jeopardized; all falls out of line...

I thought that by now, he'd change his foolish ways...
Acting as if innocent, is the image he portrays...

Clicking off his emails, as I walk on by...
Blocking not to let me see, I can't pinpoint why...

Angered by his actions creates intensity...
Engaged in women's profiles is his propensity...

Sneaky he is, behind my back, makes him kind of wildish...
Become a man, build the trust, and stop acting so childish...

Reveal the secrets; give me your code, before I find you out...
Give me reasons to believe, so I don't have to doubt...

Believe in giving chances to make things good and right...
Otherwise, don't do a thing; continue to swear and fight...

Why put your loved ones through such emotional stress...
Honesty is the best policy to solve this ugly mess...

November 13, 2009

The Forgotten Ones

Living in the projects is scary, dangerous, and rough...
For people with low income, who just don't make enough...

Applications pile-up due to the economic crisis...
Surrounded by drugs and crime; I'm making sacrifices...

Always get the run-around when things need to get fixed...
Forgetting that we are people of all colors, pure and mixed...

To dwell in better buildings I make too much or little...
Can't ever move up because I'm always stuck in the middle...

Our voices aren't heard; we're not loud enough or outspoken...
I'm living in a nightmare from which I have not yet awoken...

We are the forgotten ones, always pushed to the side...
Still, I walk with my head up with dignity and pride...

Judged and labeled by society as ghetto, losers and low-lives...
Power to those who excel and to the one who survives...

Survival of poverty makes you strong-minded and humble...
Otherwise, it depresses, corrupts and makes you stumble...

Life continues to get harder, but I will continue to strive...
Won't let society get the best of me, as long as I'm alive...

It's time for change and equality and overdue reform...
Don't judge a book by it's' cover, which has always been the norm...

March 17, 2010

Triumphant

I may not be a model, a princess, or a queen...
My beauty comes from deep within; beauty that can be seen...

I may not be filthy rich; I don't have any money...
Peace of mind I treasure; it's much sweeter than honey...

Reluctant and scared was I, to move forward in life...
The wound was deep and so intense, sharp as a knife...

My boring life has changed; I took it to another level...
Kept the angel on my shoulder; shook off the sneaky devil...

Triumphant and victorious I am, for making it to the top...
Left all the tears behind me; didn't cry a single drop...

I may not have a house, a ranch, or fancy mansion...
My home is my sanctity; full of character, and expansion...

I have no authority, fame, or crystal ball...
I stand here before you, so proud, strong, and tall...

My soul is fully recovered; I've regained my self-respect...
Ready for what lies ahead; but don't know what to expect...

There's more to life than riches; it's all material stuff...
The riches I choose are peace and love; it's more than enough...

September 10, 2009

Triumphant

Victory Is Mine

My life was dead and boring, but today I'm much alive...
Doing what it really takes to live and to survive...

With suicidal thoughts in mind, I wanted to end it all...
Confused with cries of despair and seeking to conquer the fall...

Destructive as a time bomb; I'm ready to explode...
When I set off, there's no deploying or numbers to decode...

My youth was slowly taken; I lost so many years....
I came to realization and conquered all my fears...

God was standing by my side, I made so many changes...
Erased mistakes, and cleansed my soul as life rearranges...

My battle is not yet over, with obstacles to overcome...
A brand new person is born and alive, my best is yet to come...

Empowered by the strength of God, victory is mine...
Motivated by his love, I focused and kept in line...

September 29, 2009

Victory Is Mine

The Polluted Mind

Anger is an emotion we sometimes can't control...
Triggered by contributing factors such as alcohol...

It's built up strong emotions we bury deep within...
Feeding the polluted mind with drinks like juice and gin...

Wounds and pain are hidden; the problem still remains...
Depression starts kicking in; leaving mental stains...

Another world we're living in with temporary insanity...
Leading to vulgarity and needless profanity...

The tears we shed are endless; the pain is too intense...
We go through many struggles; it doesn't make much sense...

Anger can cause to take a life and leads to suicide...
Professional help is my advice; don't just run and hide...

Talk to someone positive, who can simply be your friend...
Talk to someone impartial, who will listen and comprehend...

Channeling our emotions can help to voice a thought...
It helps overcome our battles to conquer what we sought...

May 25, 2010

The Power of Love

The magnitude of love is a powerful source...
It's not to be played with; it's not just intercourse...

Full of eccentric feelings mixed with strong emotion...
To be loved and love back consists of great devotion...

The touch of a hand feels unique and quite intense...
Nothing else really matters because love is so immense...

The heart muscle beats at an unusual rapid rate...
You can only feel these effects with your true soul mate...

The kiss is so juicy, delicious, warm, and tender...
This man who I love is confident of his gender...

The words sound golden, strong, and bitter sweet ...
Words alone cannot shape love to make it complete...

The beauty of love comes from deep within our hearts...
The power of love never dies; it separates then departs...

Confused by these feelings, which puts us in a trance...
Don't be afraid to open up, just give yourself a chance...

Be ready for uncertainties, which seem as clear, as day...
Prepare for the opportunity when love comes down your way...

March 4, 2010

What Is Your Purpose?

We're never prepared to face a world full of confusion...
A world of reality, uncertainties, and a tainted illusion...

We all have purpose in life and discover it as we evolve...
Some able to fulfill it before life evaporates and dissolve...

Others are left unknowing what their purpose will ever be...
Wasting valuable time so nonchalantly and carefree...

Excited by freedom of knowledge; a true and reliable source...
It helps to expand purpose and let's life take its' course...

An open mind with confidence is advice to all and each...
Don't allow negativity that's close within your reach...

It's defeating the purpose for which we desperately seek...
Failure is not an option; it makes you meager and weak...

Knowledge is power; it opens many doors and provides detail...
We can't predict the future, but have the desire to prevail...

My purpose is to inspire by writing; it sends a message to all...
Reaching to out to people of all ages, gender, big and small...

What is your purpose and reason for your very existence?...
Show it with devotion, enthusiasm, and persistence...

May 21, 2010

What is Your Purpose?

Time to Come Together

Tis the story of a girl who loved her mom to death...
She'd give her the world if she could including her last breath...

Silenced by a secret that left her mentally unstable...
Afraid of being stereotyped, blamed, and stamped like a label...

Struggling through adolescence; this she never forgets...
Ridiculed by bullies; being born is what she regrets...

As time flew by she stayed strong, and had kids of her own...
She raised them well, they grew up; the secret remains unknown...

Never forgetting her mother, she called all that she could...
Despite the domestic abuse, she did what a daughter should...

She freed herself from torture and moved on to better things...
She found herself an angel and wanted to clip his wings...

This angel vowed to protect her from all that's evil and mean...
She became his potent drug, which is hard to leave and wean...

A fatal illness her mom acquired but she lives so far away...
Leaving to be by her side was a small price to pay...

Confused with mixed emotions on what's to come ahead...
Trying to face reality that she'll be gone not dead...

Time to come together to join for one last chance...
No time to stab with daggers that hurt our mental stance...

October 12, 2010

Words To Live By

Silence is golden; a good tool in avoiding conflict...
A person with no tongue or ears is who I best depict...

The bigger they are, the harder they fall...
The smaller they are, the more they will stall...

You've got the whole world in your hands, how can that be?
The world is enormous, a lot bigger than you and me...

Love is blind, and that's absolutely true...
That's why I can't see; you just have no clue...

You can lead a horse to the water, but can't make them drink...
Your better off bathing them because they truly stink...

Mind over matter is considered a remedy for pain...
Funny, when your head hurts matter takes over the brain...

The apple doesn't fall far from the tree; a matured seed...
My children are my apples; the mirror of me indeed...

Words of encouragement are good words to live by...
Negativity creates bad words; I take we all know why...

October 11, 2010

Yes, I Can

You are proof that it can be done and so it is written...
Overcoming obstacles that worried you mentally with smitten...

A challenge it was with a good price to pay off in the end...
You have been blessed with a special gift; you are a god-send...

You fought hard on a tough battle and became the champ...
You did it with the gracious help of a genie in your lamp...

The genie that tucks you at night and wakes you to go to school...
The genie that stuck by you at your worst and became your tool...

The tool of belief that above all you will strive and excel...
The tool of love that picked you up when you faltered and fell...

Be true to your genie, for there will be no other of her kind...
She is rare but special and very difficult to find...

I am proud to be the aunt of such an ambitious young man...
The one who struggled and chanted loudly "Yes, I can...

Congratulations on a job well-done with pride and grace...
Today you are honored with recognition for this hard race...

We all have faith that you will persevere and succeed...
God will help you walk your path whenever you're in need...

September 23, 2010

In Loving Memory of

Luz Mitchell

November 23, 1946
October 15, 2010

Osceola Memory Gardens Funeral Home
1717 Old Boggy Creek Rd
Kissimmee, Florida
www.osceolamemorials.com